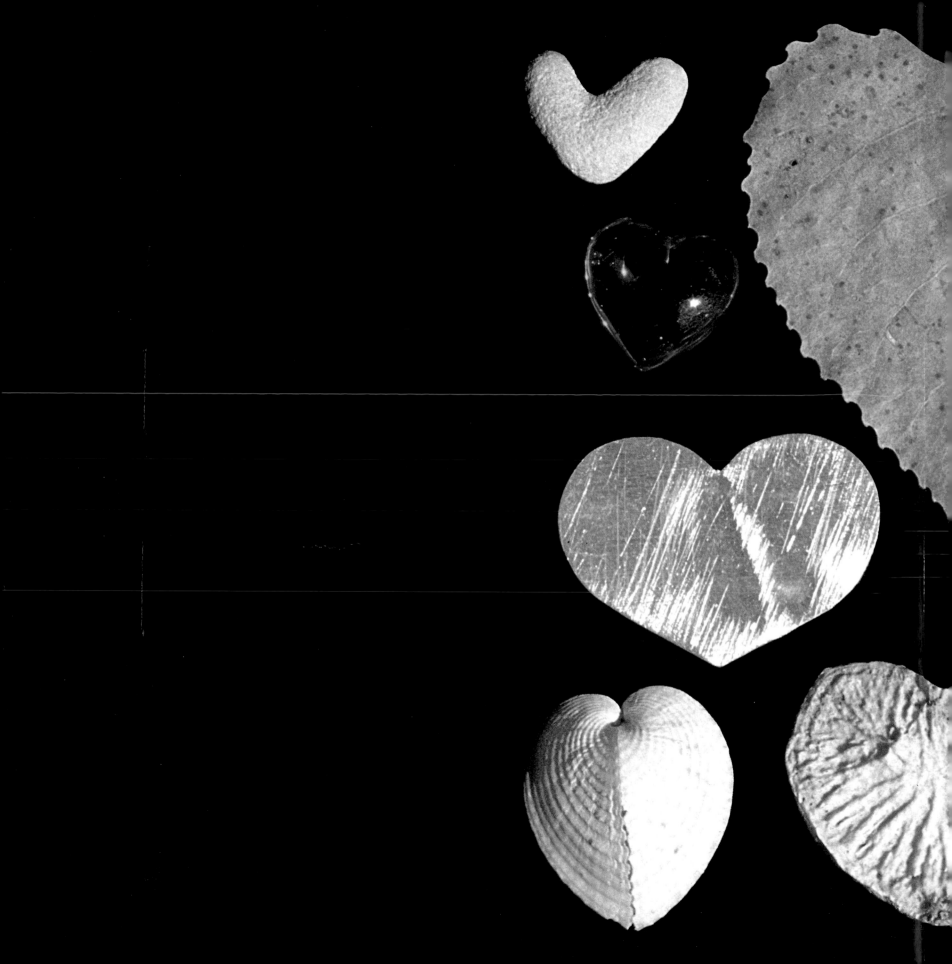

Here's a sigh to those who love me,

And a smile to those who hate;

And, whatever sky's above me,

Here's a heart for every fate.

Lord Byron

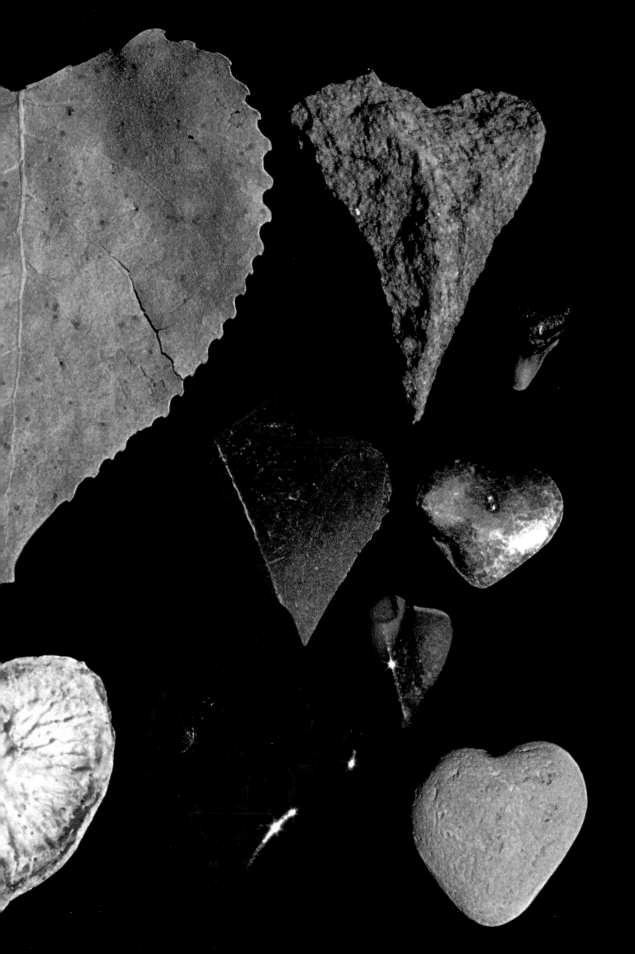

New York, New York

Albano Guatti wishes to thank the following

Antonia Miletto • Maurizio e Luisa Tosi • Marco de Plano • Johnathan and Helena Stuart • David Metz
• Marianna Guerresco • Aldo Bonzi • Canon U.S.A. • Canon Italia • Graphicolor, Rome • Altex, Turin

■ ■ ■

Designed by Marilyn F. Appleby and Gerald Boyer Cook.

Edited by Lori L. Adkins, with the assistance of Kathleen D.

Valenzi, Ross A. Howell Jr., Mary M. Wheatley, and Amy K. Lemley.

Photography copyright © 1989 Albano Guatti.

Library of Congress Catalog Card Number 88-62455

ISBN 0-943231-17-5

Printed and bound in Italy.

Published by Howell Press, Inc., 2000 Holiday Drive,

Charlottesville, Virginia 22901. Telephone (804) 977-4006.

First printing

HOWELL PRESS

HEARTS

PHOTOGRAPHY BY

ALBANO GUATTI

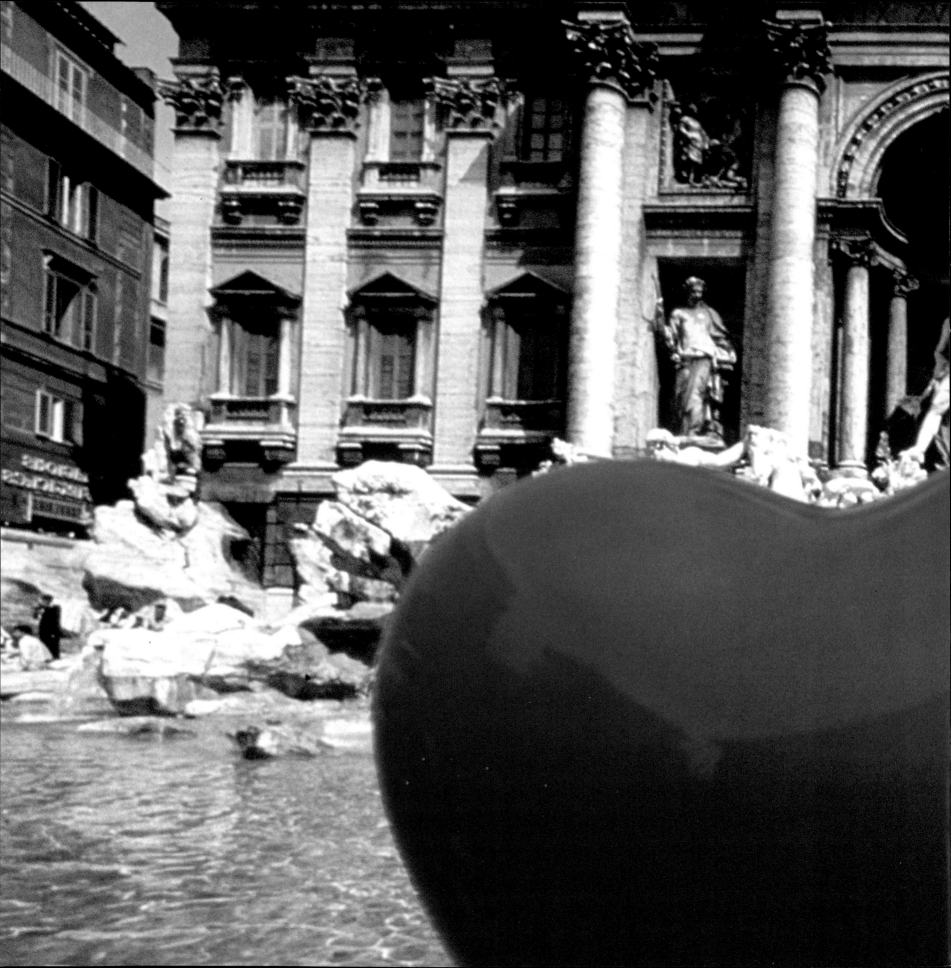

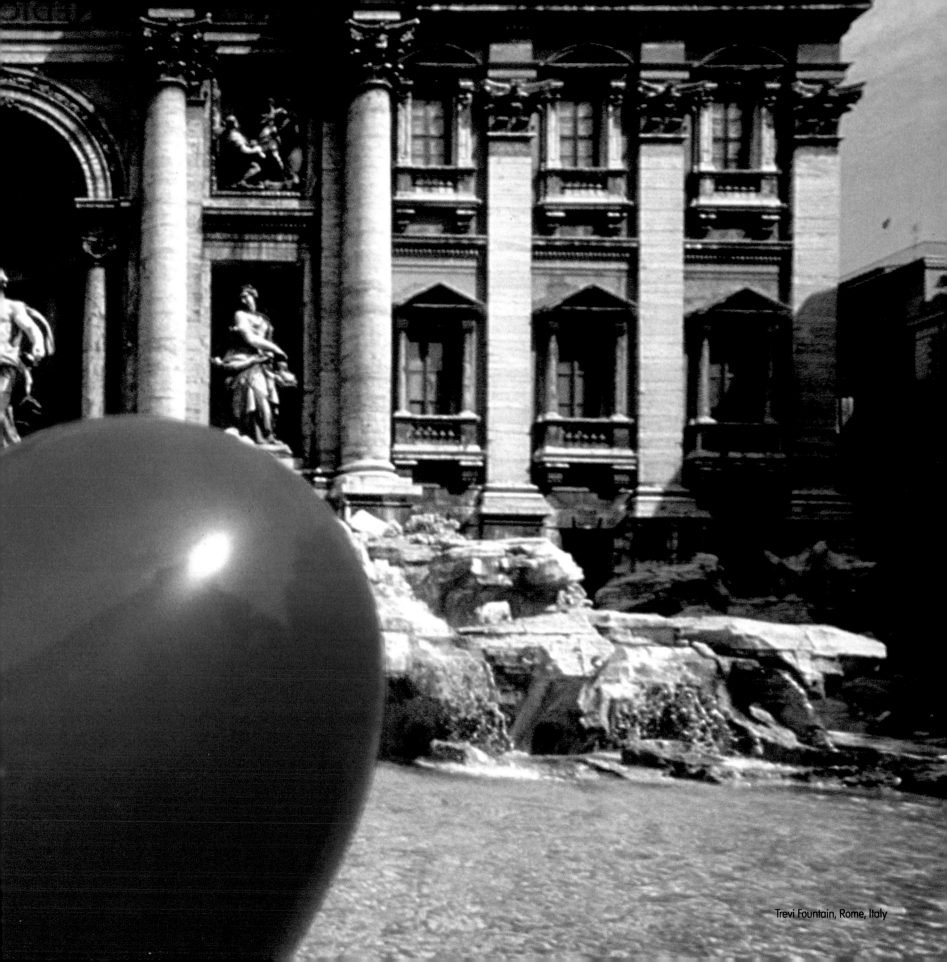

Trevi Fountain, Rome, Italy

Considered to be the seat of affection, the home of the soul, and the location of a person's courage, the heart has infused the English language with many expressions.

When two people fall in love, they may **wear their hearts on their sleeves** and will be **heartsick** if the relationship doesn't last forever. If the **heart-struck** pair is famous, gossip columnists may speculate on how long the romance will last before the **heartthrobs** will have **changes of heart.** Fortunately, jilted lovers must only endure their **heartache** until they **lose their hearts** to someone new.

Even if new romance should suddenly **tug on their heartstrings,** however, former lovers can be left **heartbroken** and experience **heart-burning** jealousies toward the new **sweethearts** of their ex-lovers. They may grow so **cold-hearted** in their attitudes about romance that rejected suitors, unable to **melt their hearts,** may claim they have **hearts of stone.**

To believe something with all your **heart and soul** is to believe it with utmost earnestness. **Heart and Soul** is also a favorite piano tune of 1938 with lyrics by Frank Loesser and music by Hoagy Carmichael. It is not to be confused with a sentimental tune from 1899 called **Hearts and Flowers,** with words by Mary Brine and music by Theodore Moses Tobani.

We could never imagine actor Humphrey Bogart delivering the line, **"Be still my beating heart,"** though emotion **tore at the heart** of many of the characters he played. A blood-thirsty pirate might refer to his shipmates as **"me hearties,"** and the **sinking of heart** that innocent passengers experience upon sighting a hostile vessel is surpassed only by their **heart-rending** screams when the pirates attack.

Both lovers and friends have **heart-to-heart** talks. With these people, we are comfortable discussing things located deep in our **heart of hearts.** Getting to the **heart's blood** of a matter in order to **set our hearts at rest** often takes time, so we extend **heartfelt** thanks to our friends for patiently listening.

A **heavy-hearted** friend might explain, "Today, I was called **heartless** by someone whom I consider to be a **bleeding-heart,** although her friends say that she's **all heart.** This person suggested that I **have a heart** and donate to a charity. Although I could **find it in my heart** to give, I just couldn't afford it."

"Take heart," you say. "You deserve the **Purple Heart** for speaking to her." Seeing your friend feel better **warms the cockles of your heart.** "Even if you had given **to your heart's content,** you wouldn't have been able to **touch the heart** of that person. Now that we've gotten to **the heart of the matter,** why don't we relax with a game of cards...maybe **Hearts?"**

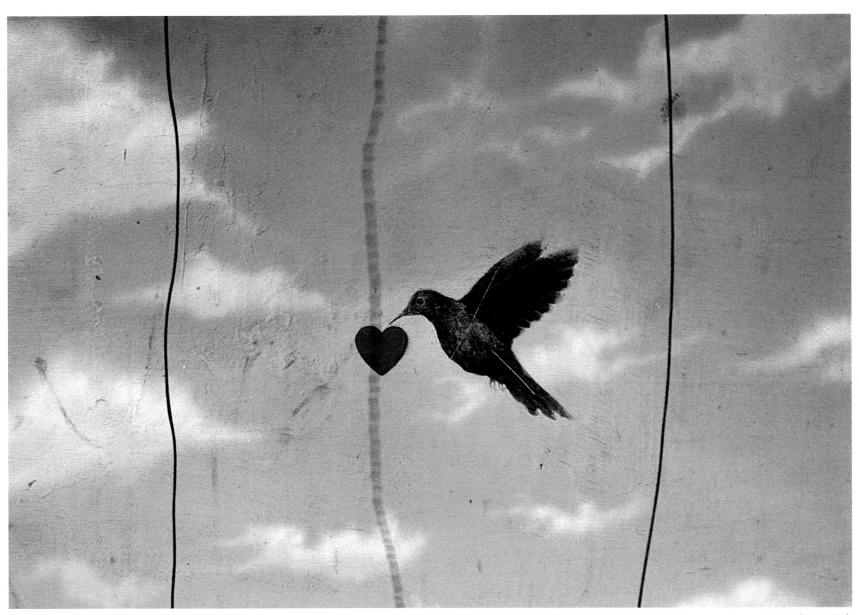

New York, New York

Albanian • zêmër	Japanese • shin
Arabic • qalb	Korean • sim kang
Armenian • sirt	Laotian • hua chay
Bulgarian • sŭrtse	Malay • jantong
Catalan • cor	Norwegian • hjerte
Chinese • hsin	Persian • dil
Czechoslovakian • srdce	Polish • serce
Danish • hjerte	Portuguese • coração
Dutch • hart	Provencal • corason
English • heart	Romanian • inimă
Flemish • hart	Russian • serdtse
Finnish • sydän	Serbo-Croatian • srce
French • coeur	Slovak • srdce
German • Herz	Slovene • srce
Gothic • haírtô	Spanish • corazon
Greek • kardía	Swahili • moyo
Hebrew • lev	Swedish • hjärta
Hindi • dil	Turkish • kalp
Hungarian • szív	Vietnamese • trái tim
Italian • cuore	Yiddish • harts

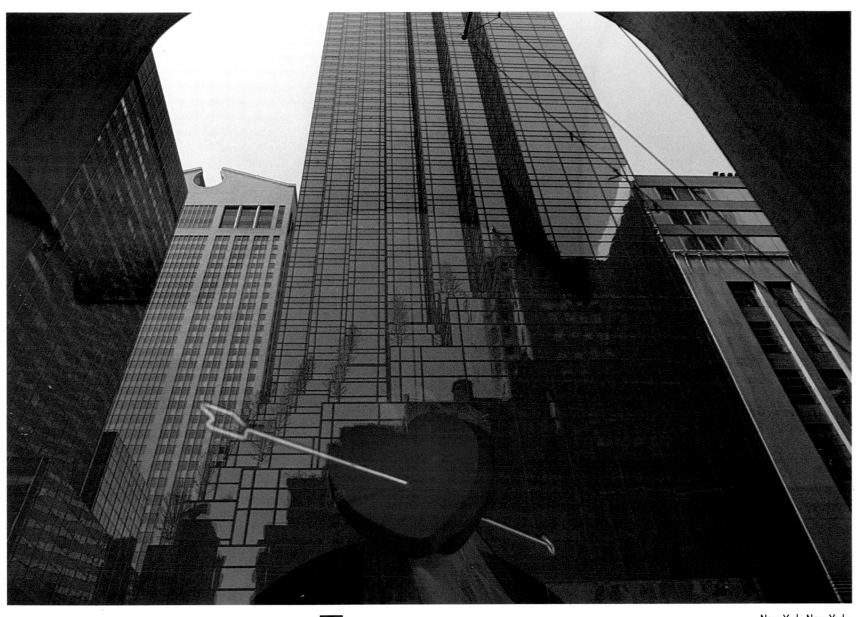

New York, New York

Thou deity, swift-winged Love,

Sometimes below, sometimes above,

Little in shape, but great in power;

Thou that makest a heart thy tower.

Beaumont and Fletcher

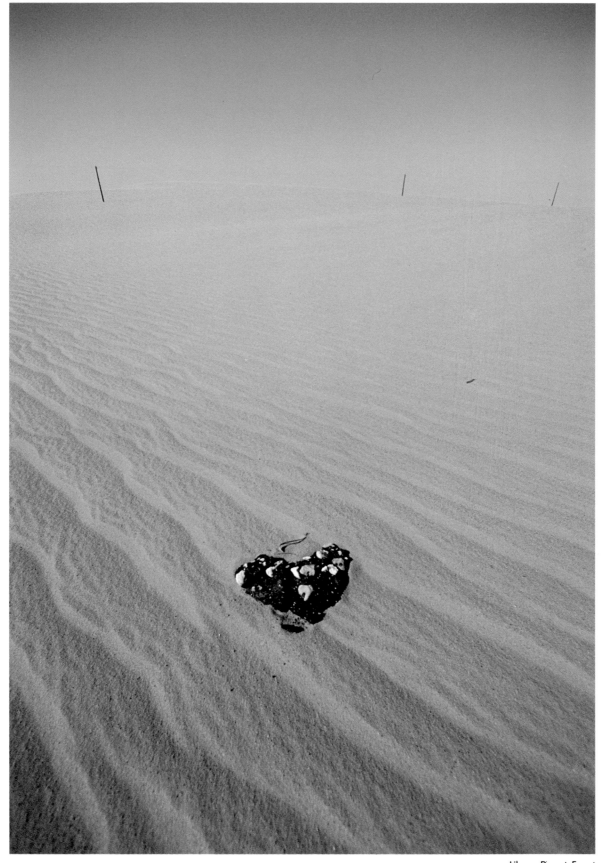

Libyan Desert, Egypt

Venice, Italy

Let thy loveliness fade as it will,

And around the dear ruin each wish of my heart

Would entwine itself verdantly still.

Thomas Moore

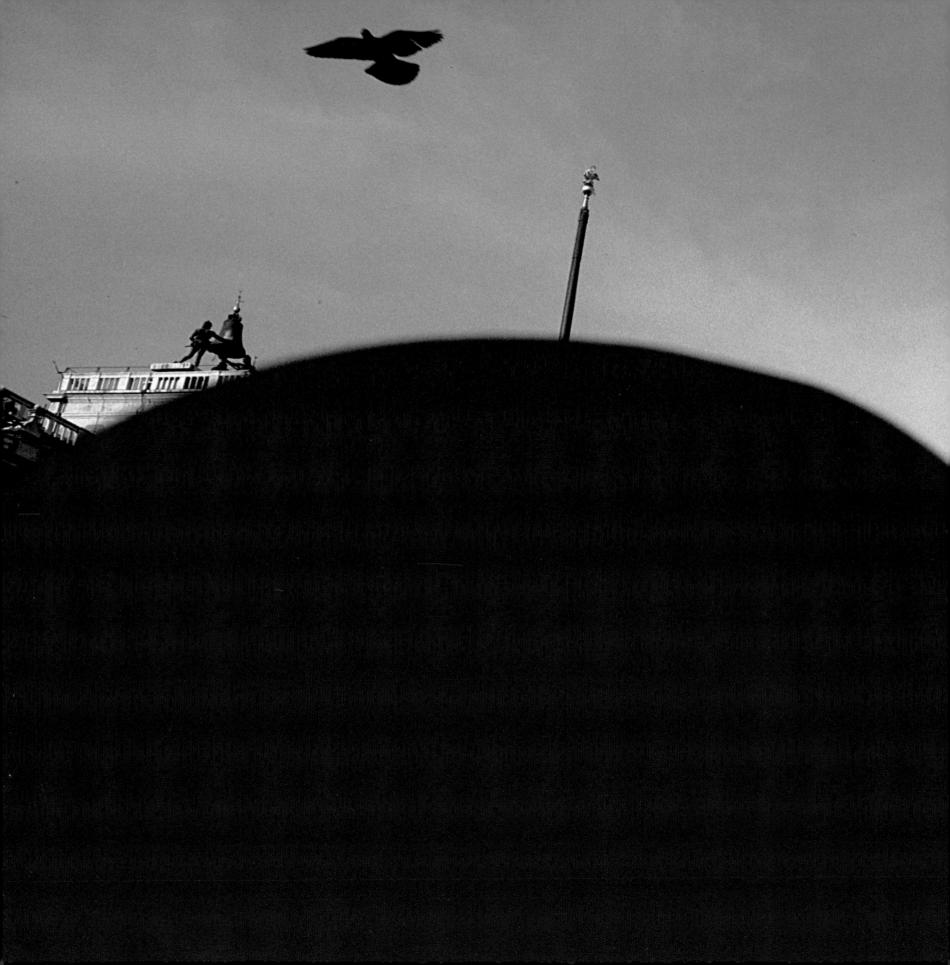

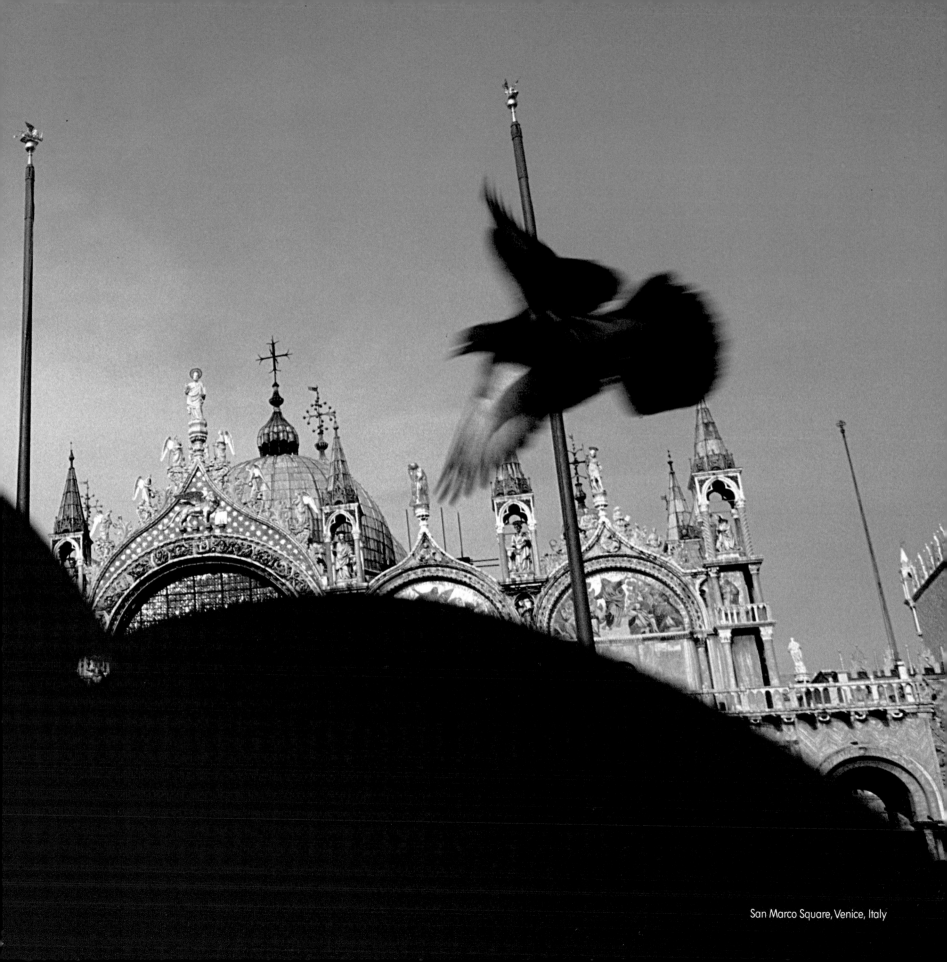

San Marco Square, Venice, Italy

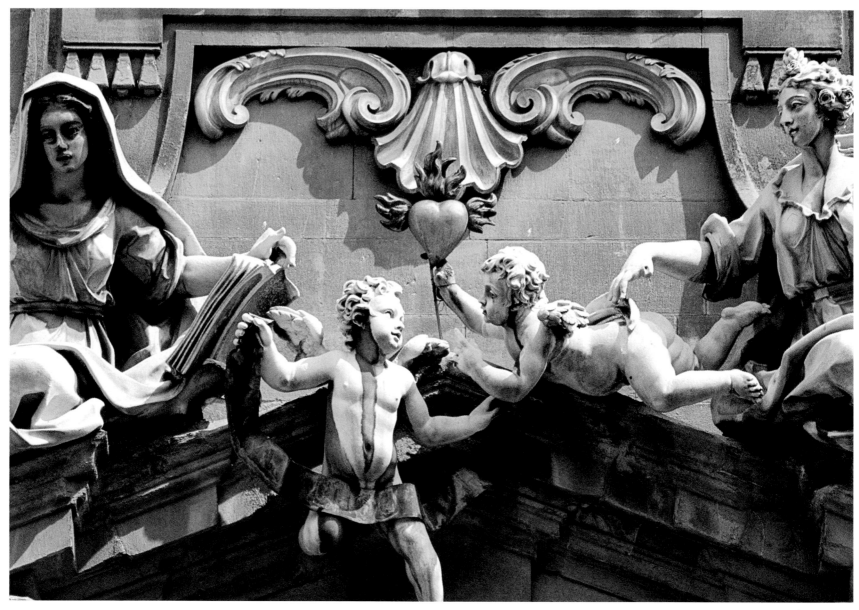

Florence, Italy

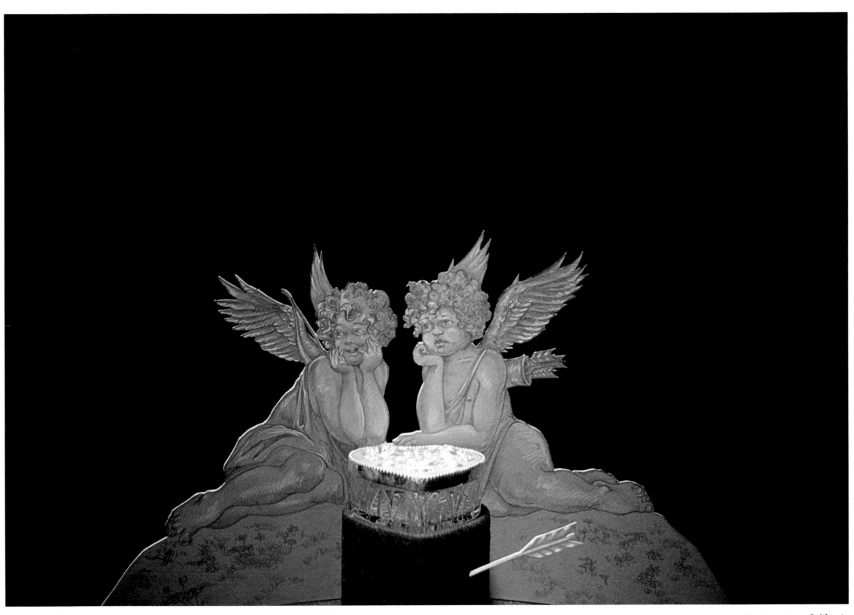

San Francisco, California

Cupid! monarch over kings,

Wherefore hast thou feet and wings?

Is it to show how swift thou art,

When thou woundest a tender heart?

Anonymous

17

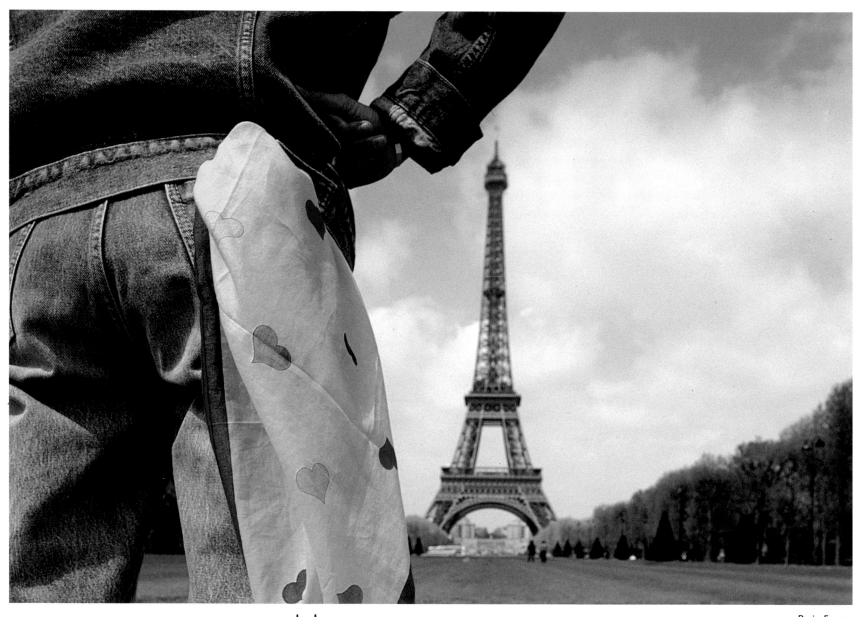

He who is light of heart when Fortune frowns,

He is a king though nameless in the towns.

Eric Mackay

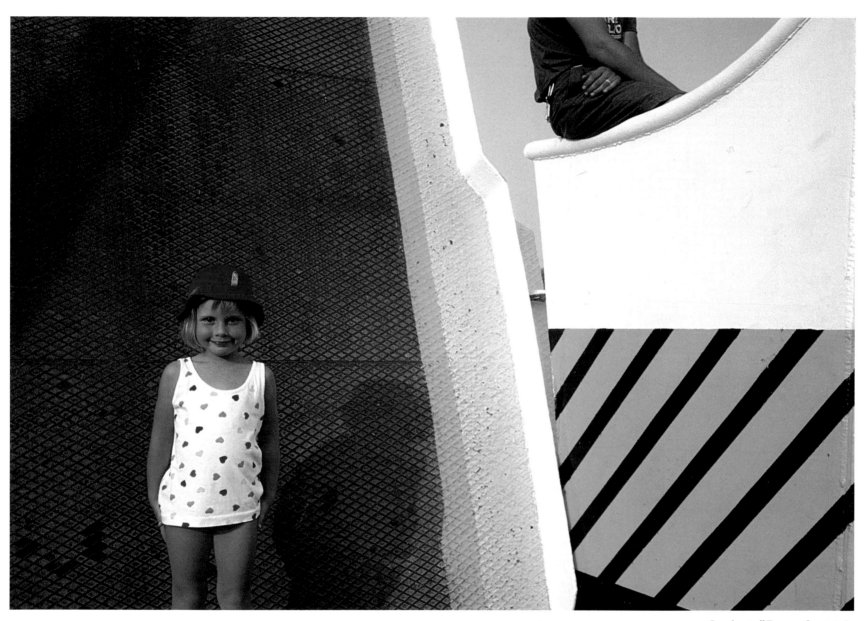

Ferryboat off Tuscany Coast, Italy

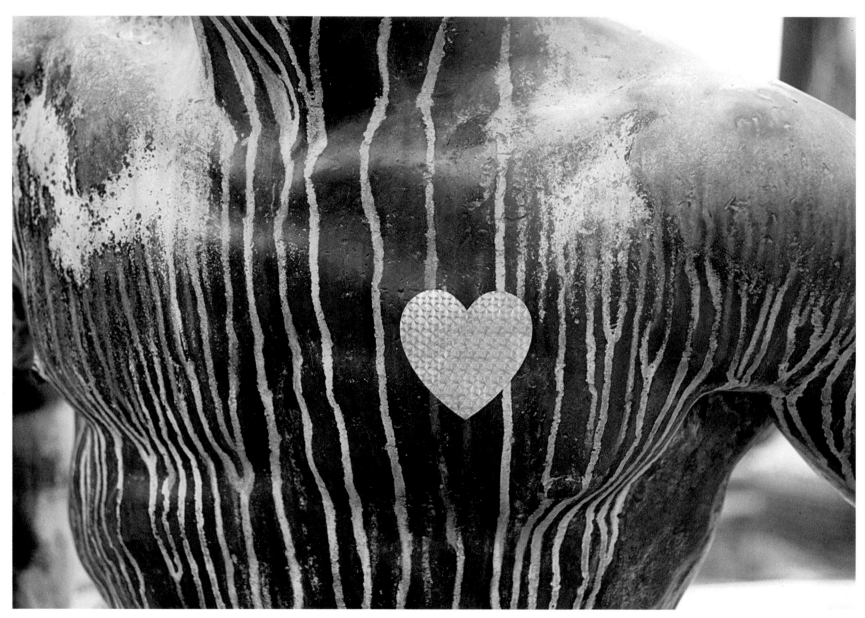

Piazza Della Signoria, Florence, Italy

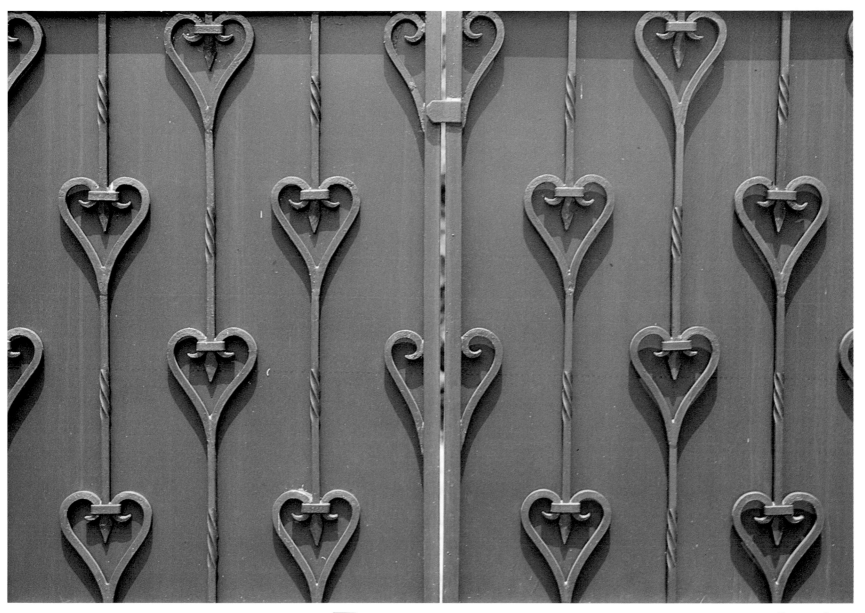

Provence, France

The Heart has many Doors—

I can but knock—

Emily Dickinson

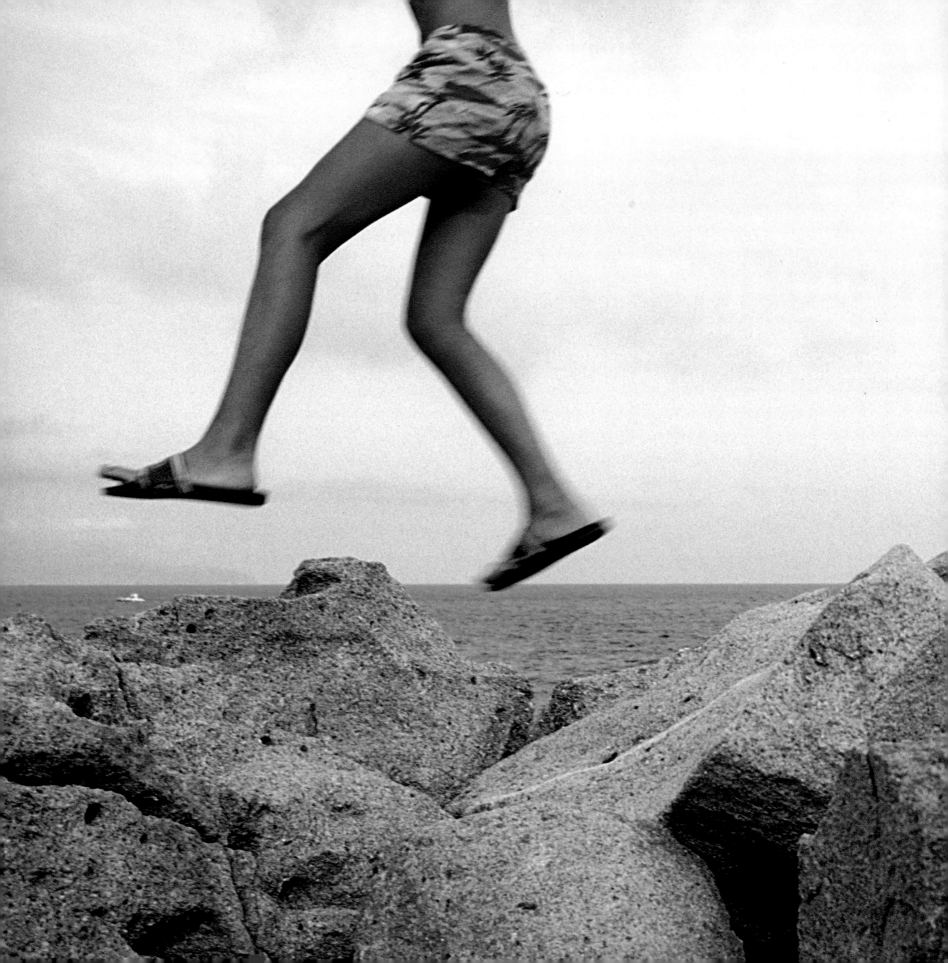

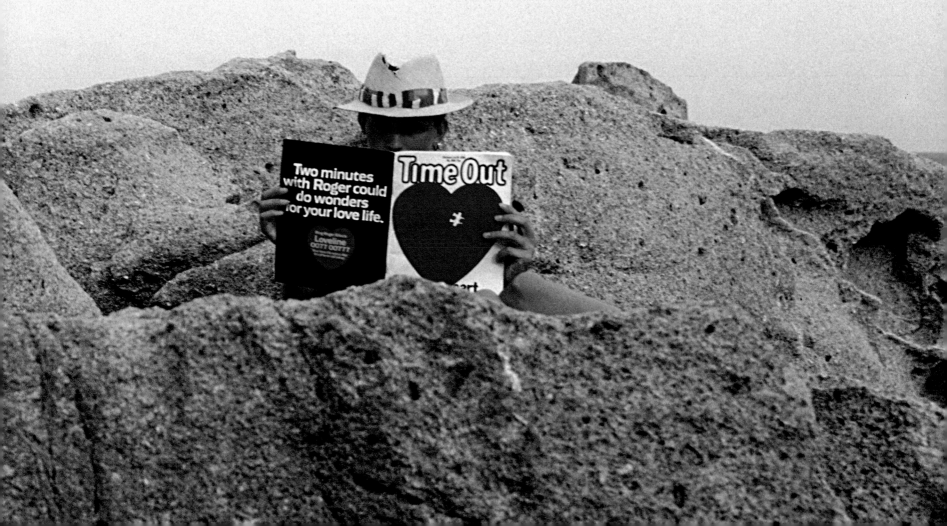

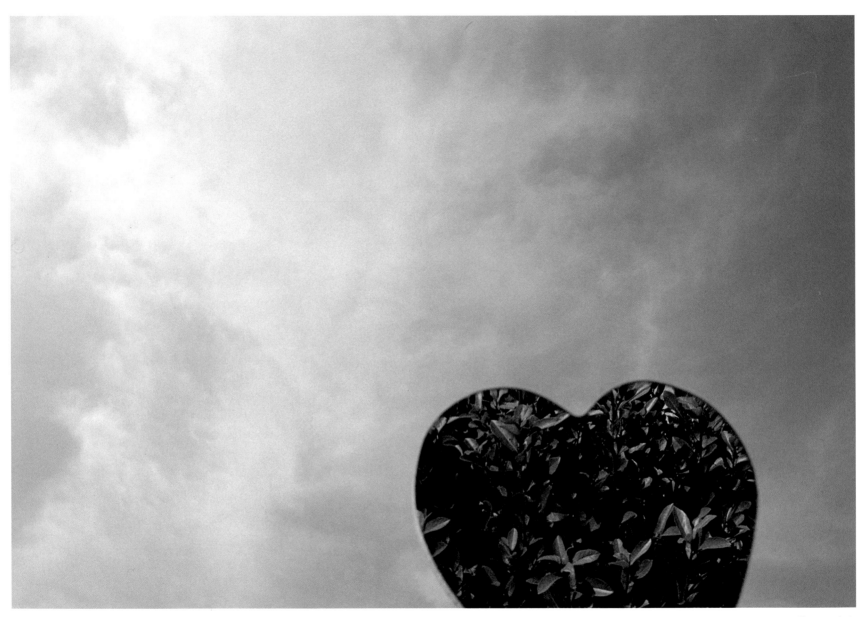

Florence, Italy

The heart is like the sky, a part of heaven...

Lord Byron

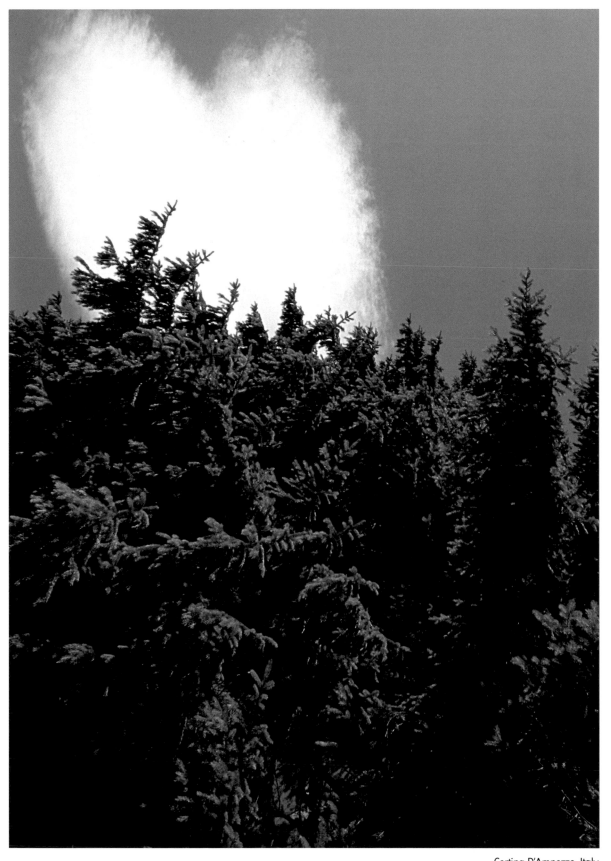

Cortina D'Ampezzo, Italy

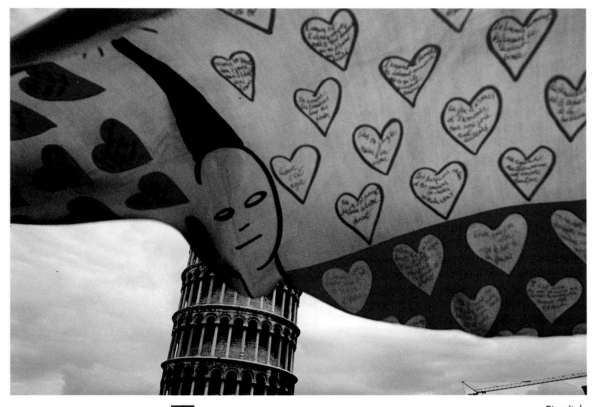

Pisa, Italy

There shall be sung another golden age,

The rise of empire and of arts,

The good and great inspiring epic rage,

The wisest heads and noblest hearts.

George Berkeley

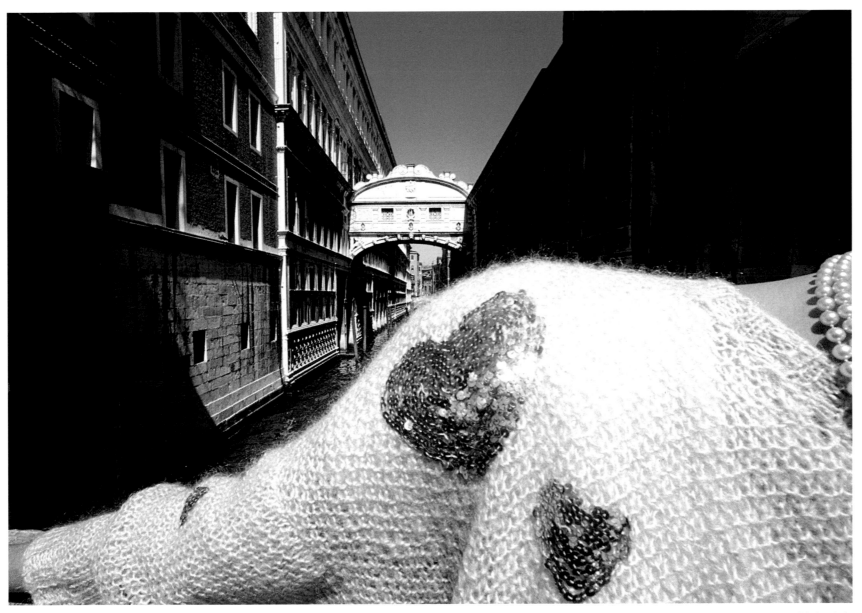

Venice, Italy

Venice, Italy

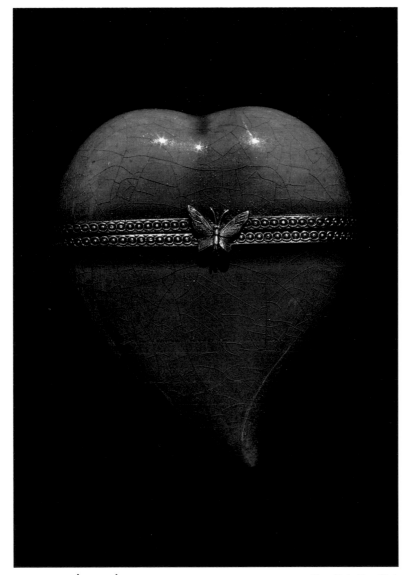

New York, New York

Whence comes my love? O heart! disclose:

'Twas from her cheeks that shame the rose,

From lips that spoil the ruby's praise,

From eyes that mock the diamond's blaze.

Whence comes my woe? as freely own:

Ah me! 'twas from a heart like stone.

John Harrington

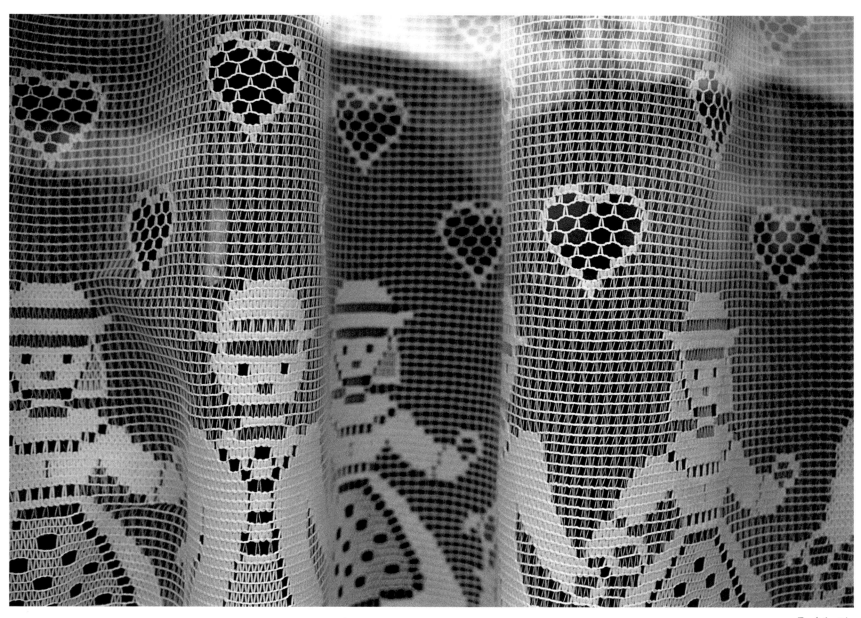

Tyrol, Austria

You and you no cross shall part,

You and you are heart in heart...

William Shakespeare

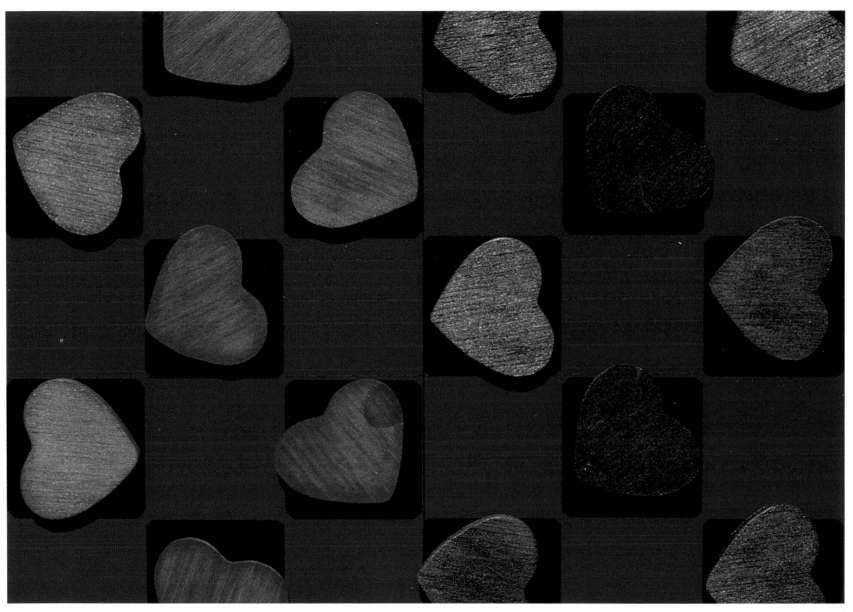

New York, New York

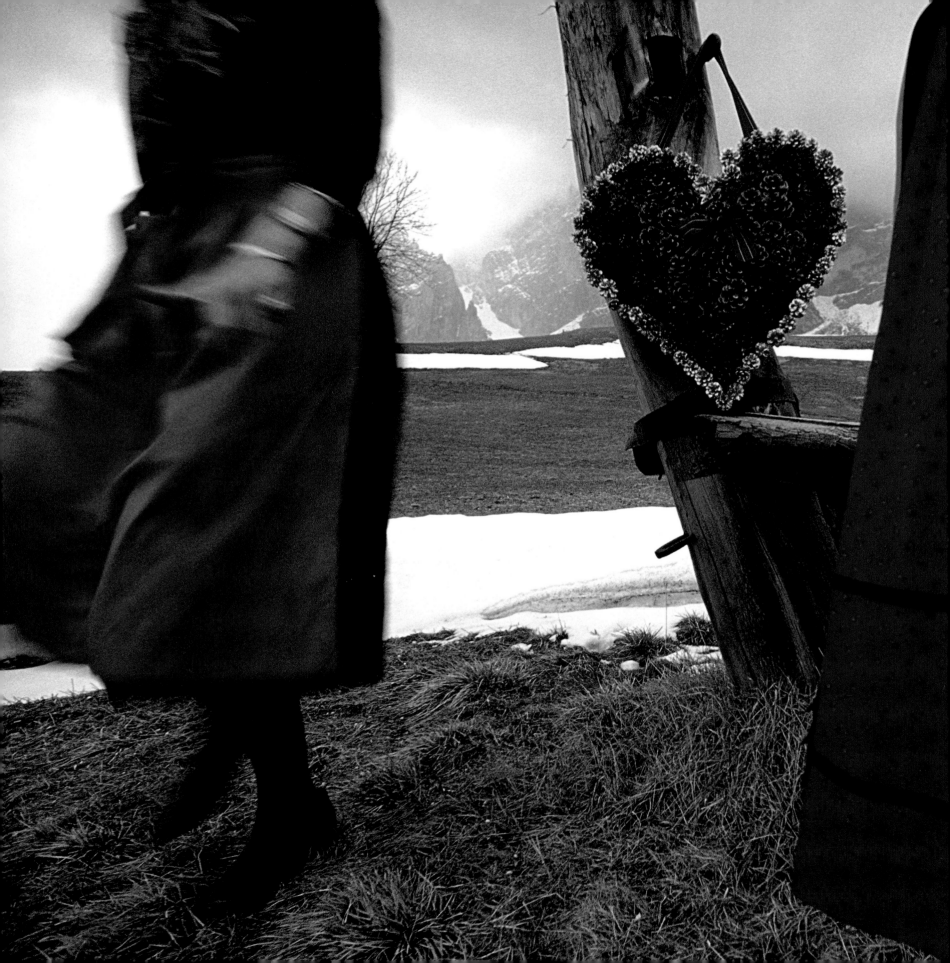

n the motion of the very leaves of spring, in the blue air,

there is then found a secret correspondence with our heart.

There is eloquence in the tongueless wind, and a melody in the

flowing brooks and the rustling of the reeds beside them, which

by their inconceivable relation to something within the soul,

awaken the spirits to a dance of breathless rapture...

Percy Bysshe Shelley

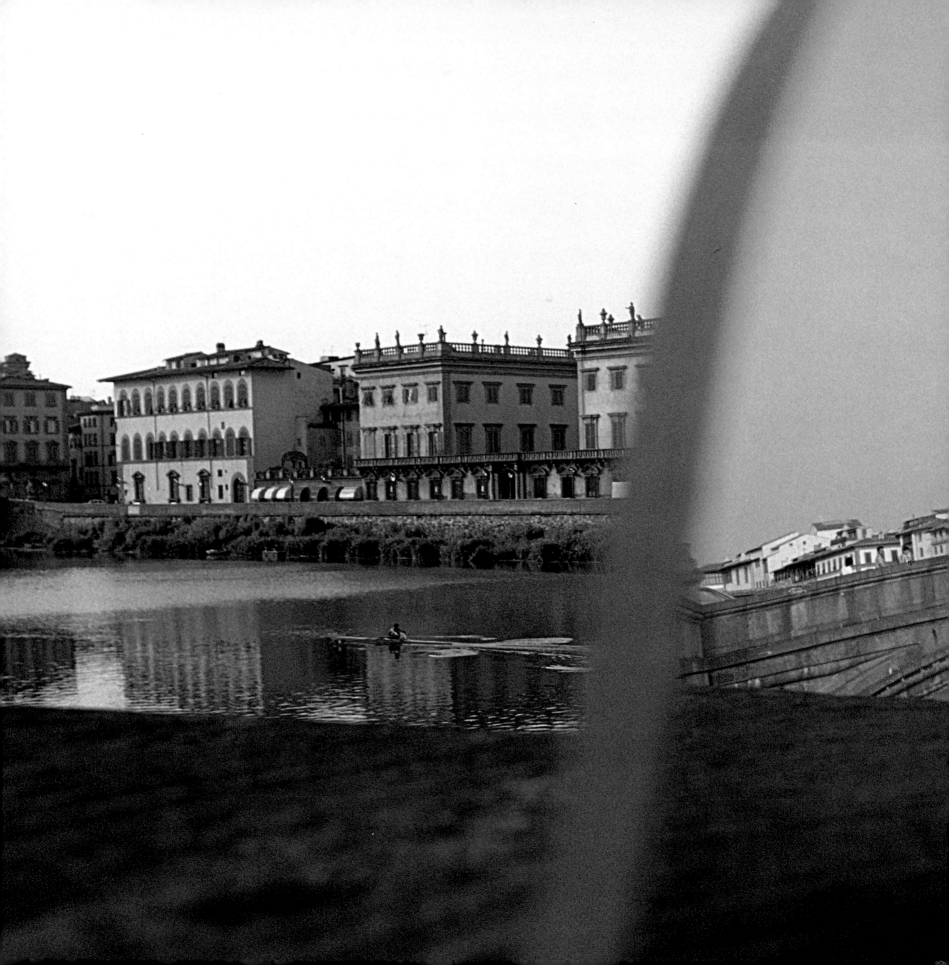

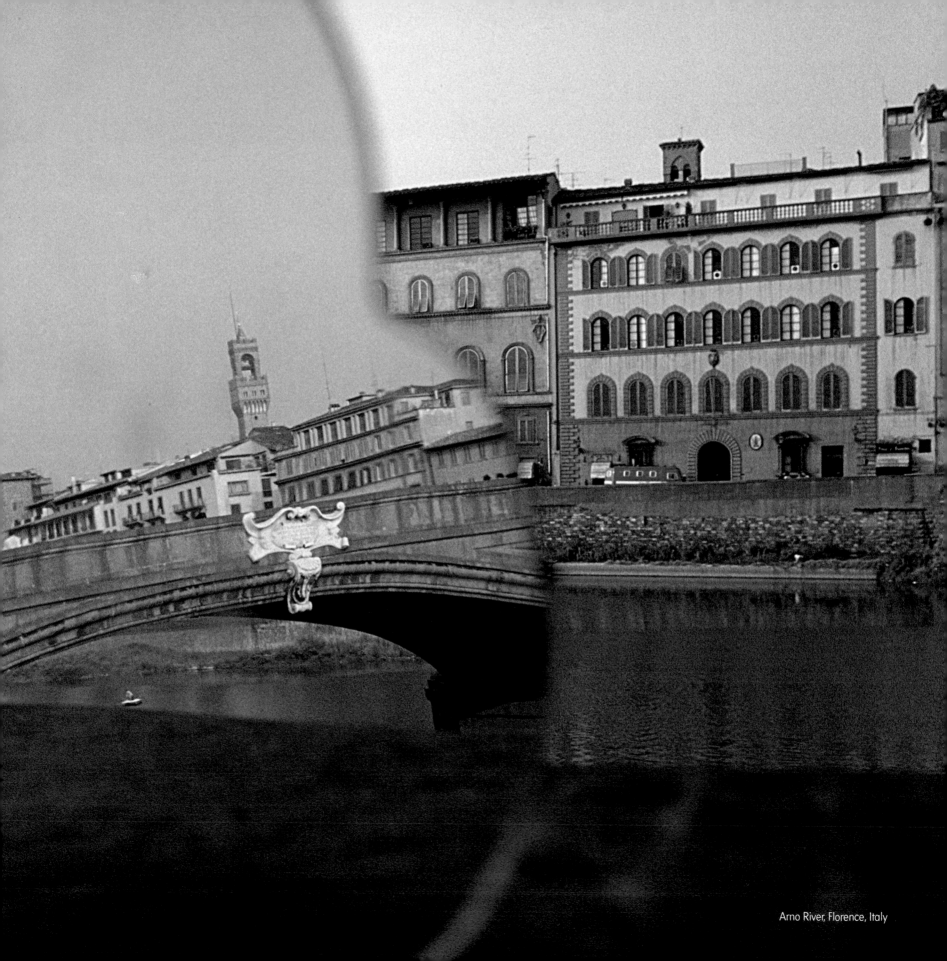

Arno River, Florence, Italy

HEARTENING PROVERBS

Absence makes the heart grow fonder. • A good heart conquers fortune. • A good heart cannot lie. • Rolling eye, roving heart. • Please your eye, plague your heart. • Prolong thy life—quiet heart, loving wife. • What the tongue speaketh, the heart thinketh. • Every heart has its own ache. • The greatest test of courage on earth is to bear defeat without losing heart. (R.G. Ingersoll) • A stout man's heart breaks bad luck. (Cervantes) • Blessed are the pure in heart: for they shall see God. (Saint Matthew) • The way to a man's heart is through his stomach. (Fanny Fern) • Home is where the heart is. (Pliny) • A man should keep his heartstrings tightly drawn. (Plautus) • There are two worlds: the world that we can measure with line and rule, and the world that we feel with our hearts and imaginations. (Leigh Hunt) • Veracity is the heart of morality. (Thomas H. Huxley) • The mind is always the dupe of the heart. (François Duc de la Rochefoucauld) • The heart has its reasons, which reason does not know. (Blaise Pascal) • My heart is where I am, such as I am. (Saint Augustine)

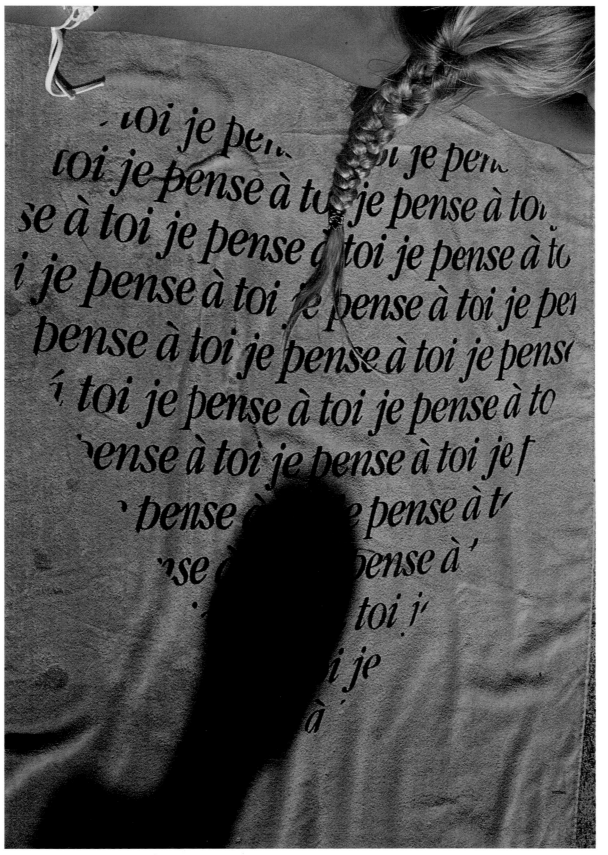

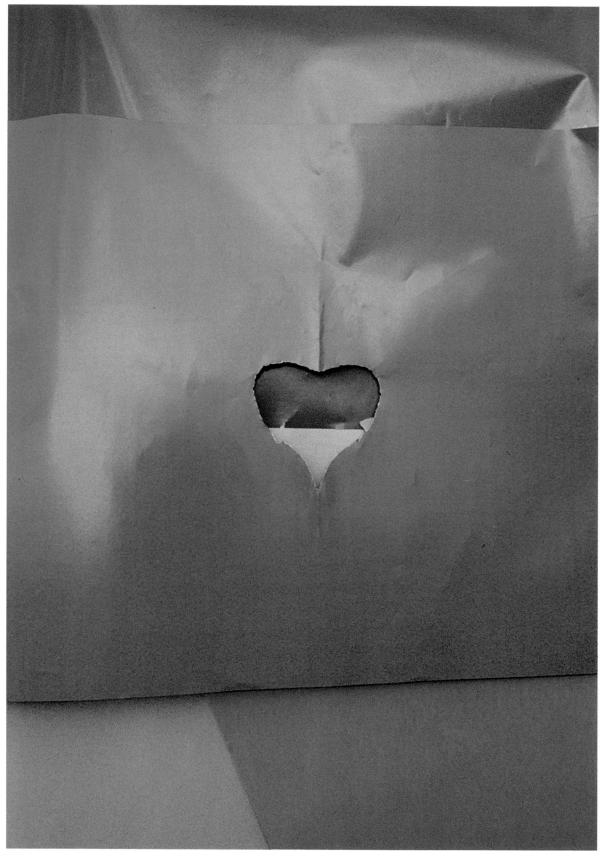

Amsterdam, Netherlands

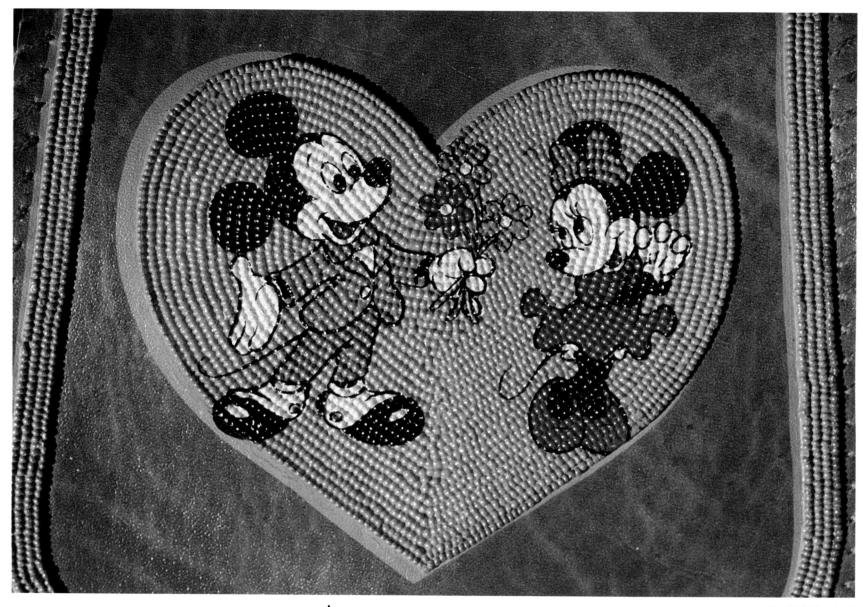

New York, New York

t's all I have to bring today—

This, and my heart beside—

This, and my heart, and all the fields—

And all the meadows wide—

Emily Dickinson

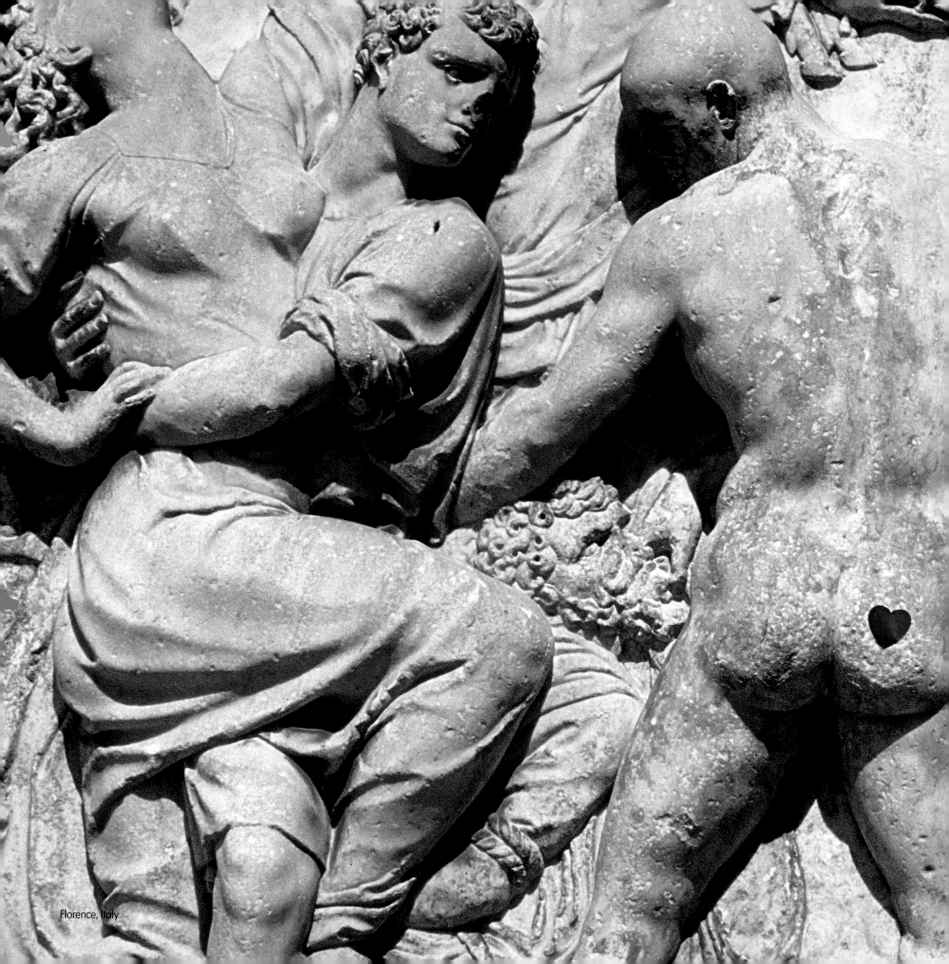

Florence, Italy

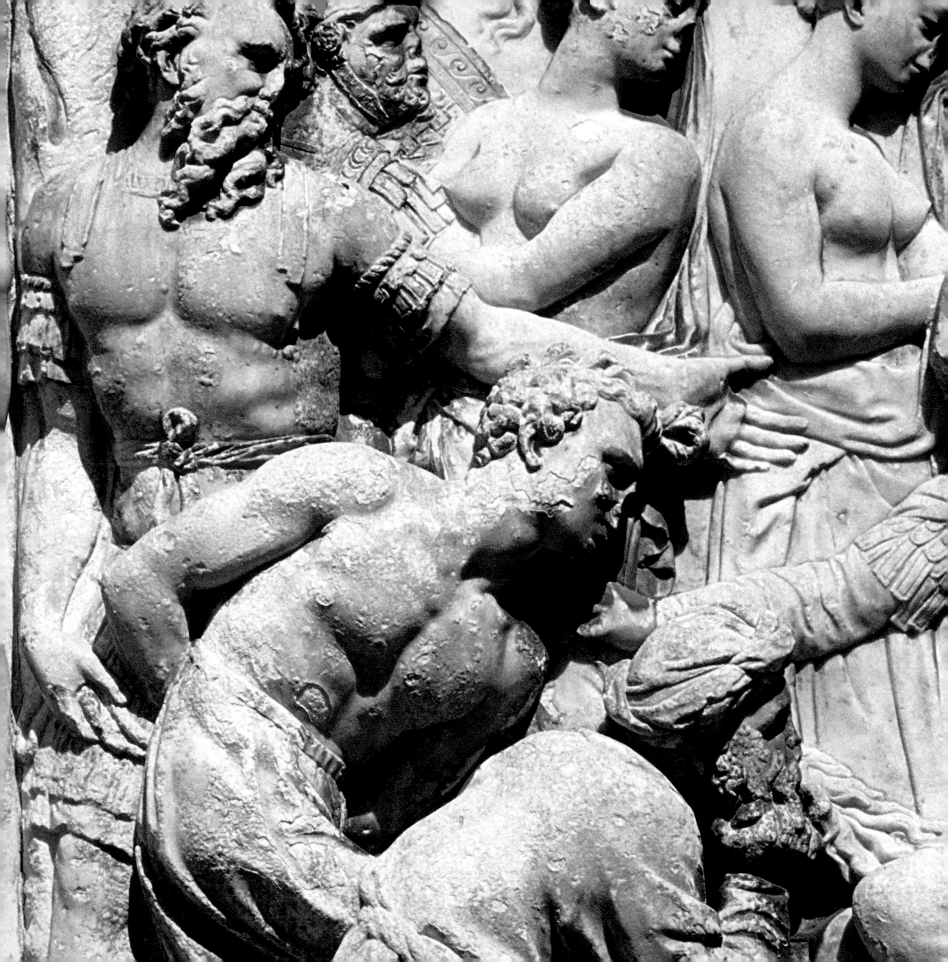

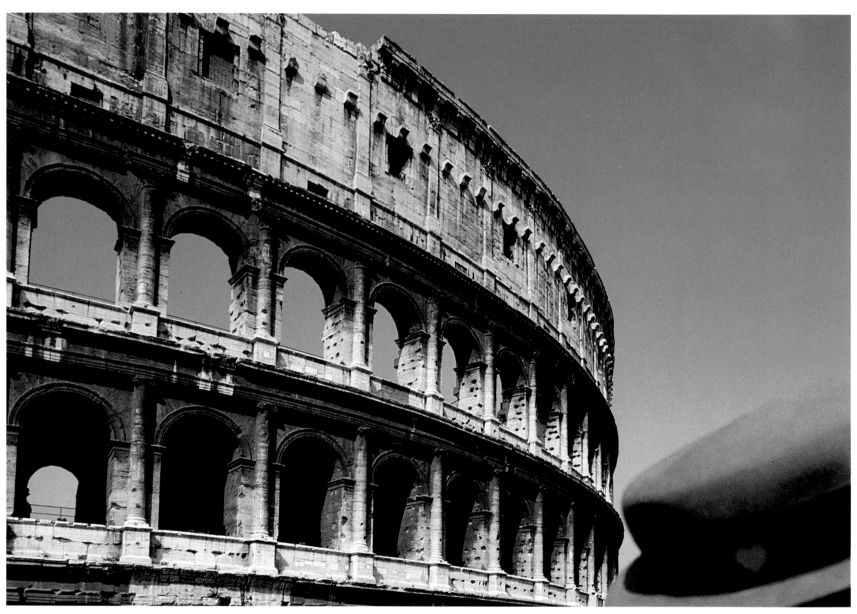

Rome, Italy

HEARTSOME TRIVIA

People used to put heart-shaped brass hardware on horse harnesses to prevent the animals from becoming bewitched. Today's version of this superstition is the heart-shaped locket.

The word "heart" is mentioned 1,024 times in the Bible and symbolizes devotion, reverence, and the spiritual nature of man. "Keep thy heart with all diligence, for out of it are the sources of life," Proverbs 4:23.

When children recite the vow, "Cross my heart and hope to die," they are invoking an oath often sworn between people and elves in myth. Those who broke their promises had to exchange their hearts for stones.

Astronaut Neil Armstrong's heartbeat soared from 77 beats per minute to 156 beats per minute when he landed on the moon in the lunar module in 1969.

In playing cards, the suit of hearts represents the ecclesiastical powers of religious leaders in medieval times. This suit is to be avoided in the card game of Hearts, first developed in the United States in 1880, just as the Queen of Hearts ("Off with her head!") was to be avoided in **Alice in Wonderland.**

Snails, earthworms, and houseflies have hearts. The lancelet, a small marine invertebrate, does not.

A flaming heart signifies love, zeal, and devotion; pierced with seven daggers, it represents the sorrows of the Virgin Mary. The heart, cross, and anchor together—found in many tattoos—symbolize love, faith, and hope. The heart pierced by an arrow —Cupid's dart—suggests love and sexual passion.

The heart rate of the world's smallest mammal, the shrew, has been clocked at 1,000 beats per minute. A human infant's heart beats 150 times a minute, compared with an adult, at 70 times per minute. The heart of a resting elephant beats 30 times a minute; an excited small beluga whale, 15 times a minute.

Alchemists believed the heart to be the image of the sun within man.

The heaviest heart ever recorded was that of a 209-ton female blue whale killed in 1947. Her heart weighed 1,540 pounds.

A heartpoint is the center of a coat of arms, a shield used in medieval times to bear heraldic messages.

At the end of 70 years, a human heart will have pumped more than 46 million gallons of blood and have beat about 2,649,024,000 times.

Florence, Italy

Young men's love then lies

Not truly in their hearts, but in their eyes.

William Shakespeare

Capri Island, Italy

San Francisco, California

San Francisco, California

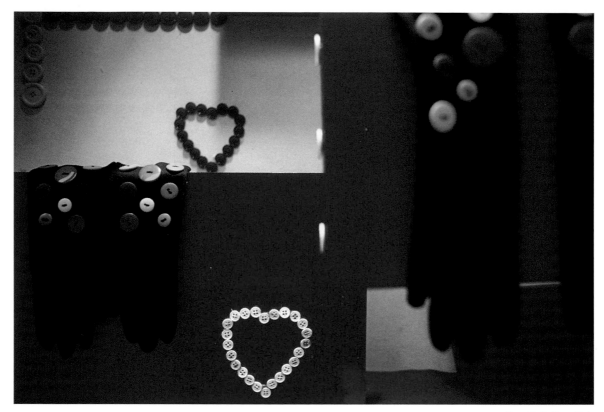

New York, New York

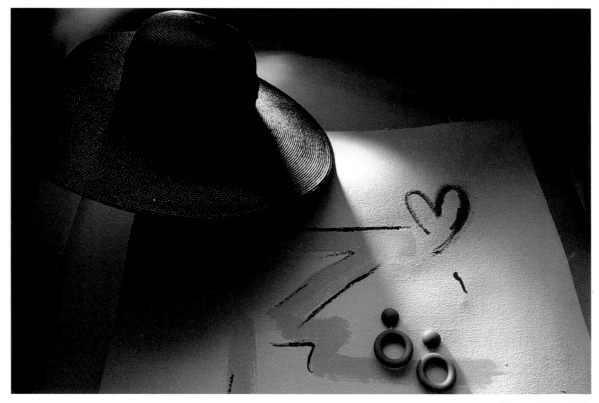

New York, New York

New York, New York

h! say not woman's heart is bought

With vain and empty treasure.

Oh! say not woman's heart is caught

By every idle pleasure.

When first her gentle bosom knows

Love's flame, it wanders never;

Deep in her heart the passion glows,

She loves, and loves for ever.

Thomas Love Peacock

New York, New York

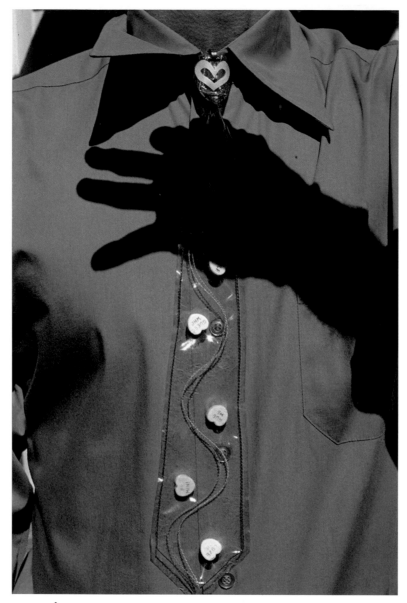

New York, New York

I said to my Heart, between sleeping and waking,

Thou wild Thing, that ever art leaping or aching,

For the Black, for the Fair: In what Clime, in what Nation,

Hast thou not felt a Fit of Pitapatation?

Charles Mordaunt

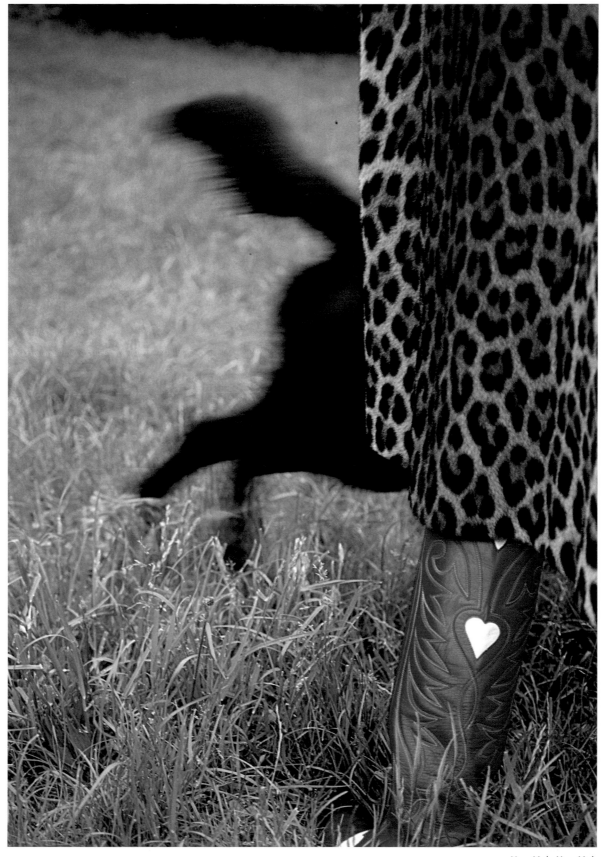

London, England

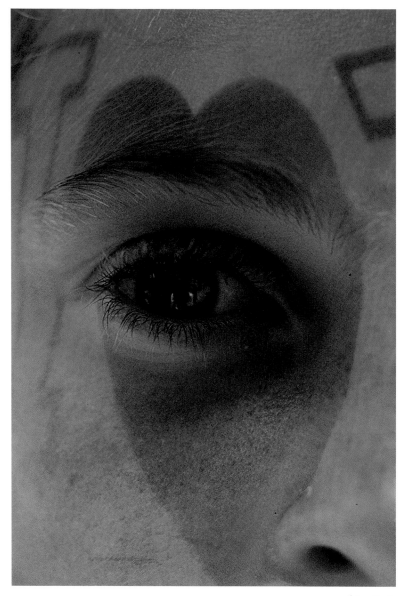

Ibiza, Spain

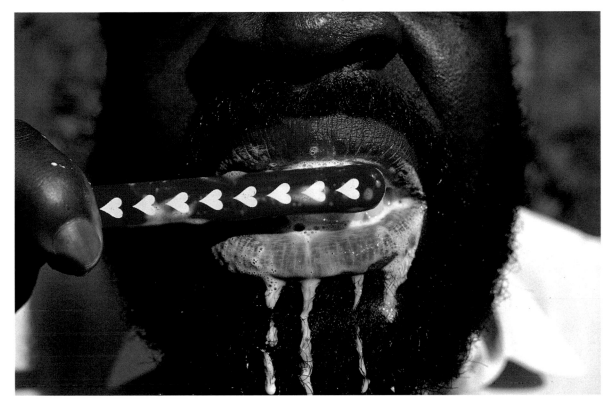

Rio de Janeiro, Brazil

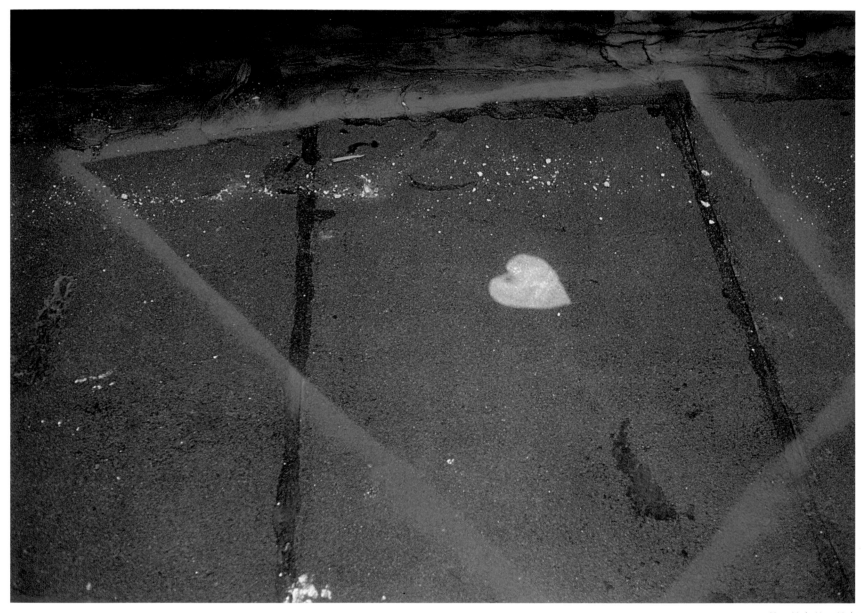

New York, New York

HEARTY CUSTOMS

Prior to Valentine's Day in Victorian times, young men would gather and draw from a jar slips of paper bearing the names of eligible young ladies. The papers were then affixed to the bachelors' cuffs for all to see. A celebration commenced, usually lasting several days, and ended with each man presenting a gift to the young lady whose name he had worn. From this tradition comes the expression, "to wear your heart on your sleeve."

In days of old, hearts were the main ingredient of love charms; girls would swallow raw chicken hearts in hopes of gaining "beauty and a beau."

Other heart-swallowing customs can be traced to tribal warriors, who ate the hearts of lions and leopards for courage and strength, or the hearts of their enemies in order to gain valor. The hearts of dead kings were consumed by their successors in other cultures for similar reasons.

The Aztecs believed that the gods of the sun and the earth required live hearts for sustenance, so during religious celebrations, priests sacrificed prisoners by tearing the still-beating hearts from their captives' chests.

Egyptians believed that in the afterlife, the heart was "weighed in the balance in the presence of Osiris," god of the underworld. Embalmers paid special attention to the hearts of the dead to ensure that they arrived safely in the hereafter.

Among the Baluba tribe of the Southern Congo, it was believed that a messenger of Kabezza-Mpungu caused the cessation of life by squeezing a person's heart until it stopped beating.

Practitioners of folk medicine believe that potions made from plants with heart-shaped leaves help people with heart disease. Likewise, herbalists used to prescribe a wild pansy called heart's-ease for heart ailments. Today, the word "heart's-ease" means "peace of mind."

Twelfth- and thirteenth-century nobles who died abroad would have their hearts sent home for burial, because they believed that the heart was the center of existence. Many monarchs were buried separately from their hearts, most notably Richard the Lion-Hearted, whose heart was placed in a basket and interred at Rouen Cathedral; Edward I, whose heart was buried at Jerusalem; and James II of England, whose heart found its final resting place in Paris. Poets Robert Bruce, Percy Bysshe Shelley, and Lord Byron also arranged separate burials for their hearts.

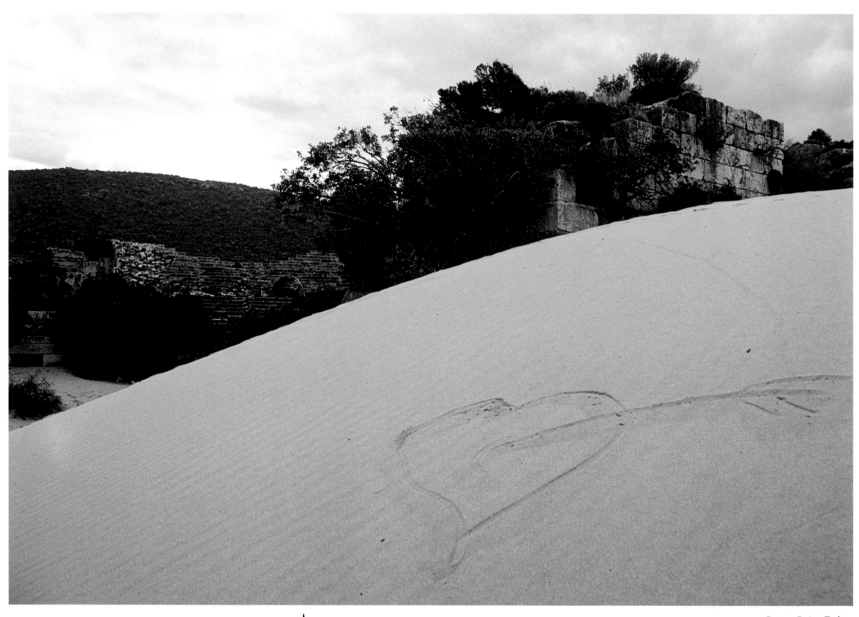

Patara Ruins, Turkey

A gracious Spirit o'er this earth presides,

And o'er the heart of man: invisibly

It comes, directing those to works of love,

Who care not, know not, think not what they do...

William Wordsworth

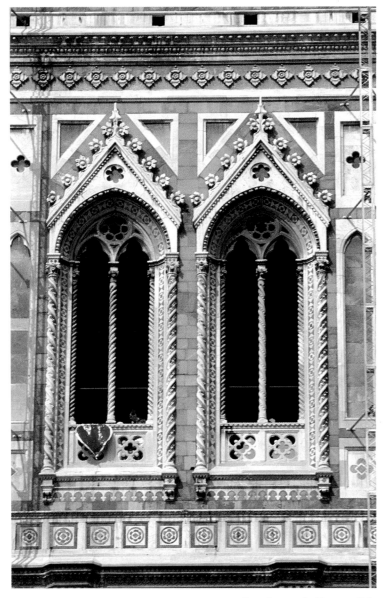

Giotto Campanile, Florence, Italy

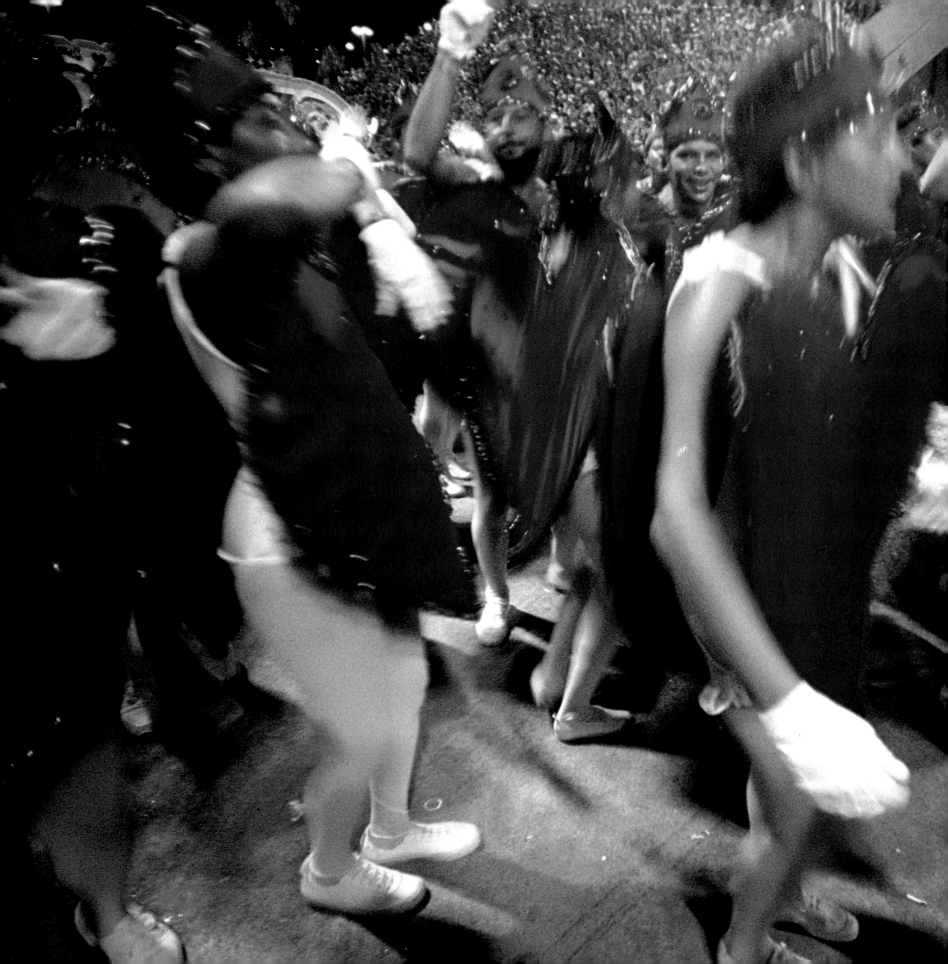

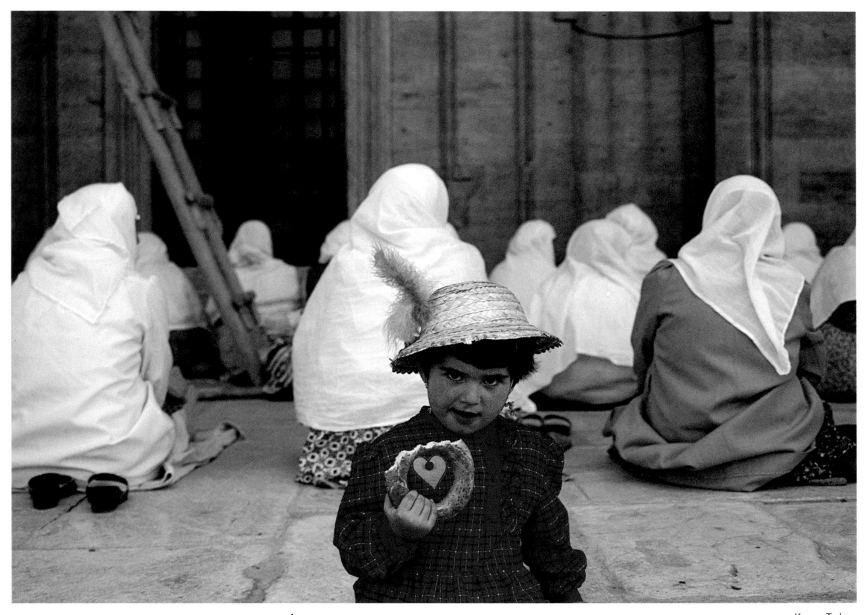

Konya, Turkey

s't well to stand apart

And gaze at me and gently break my heart

Without one word?

Eric Mackay

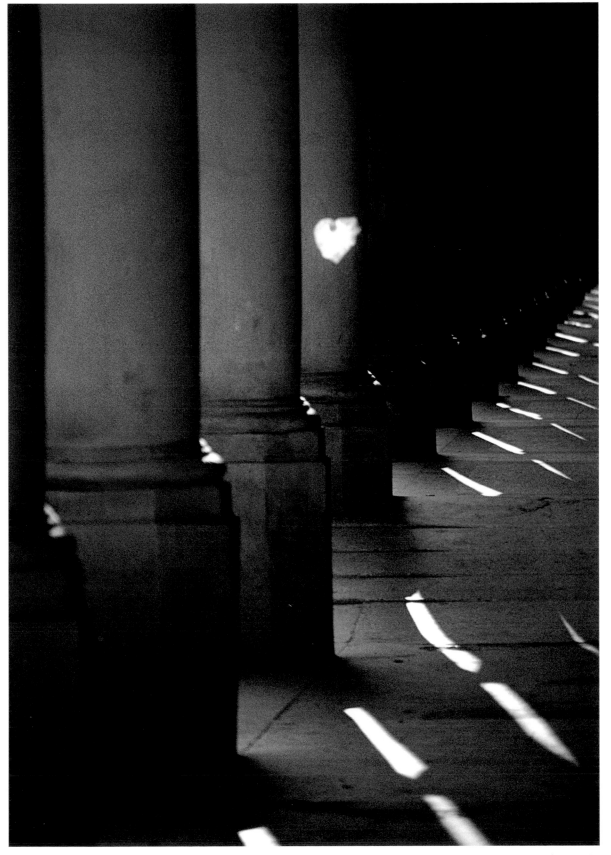

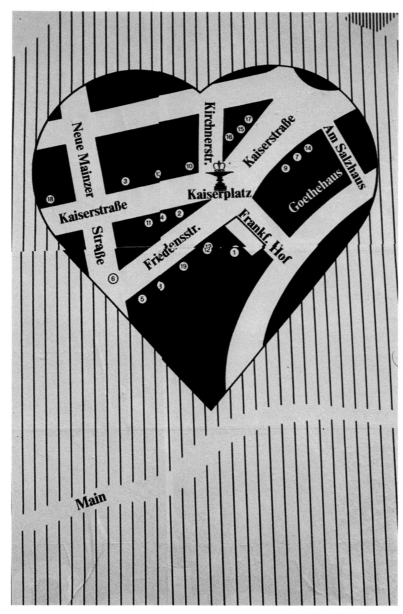

Frankfurt, West Germany

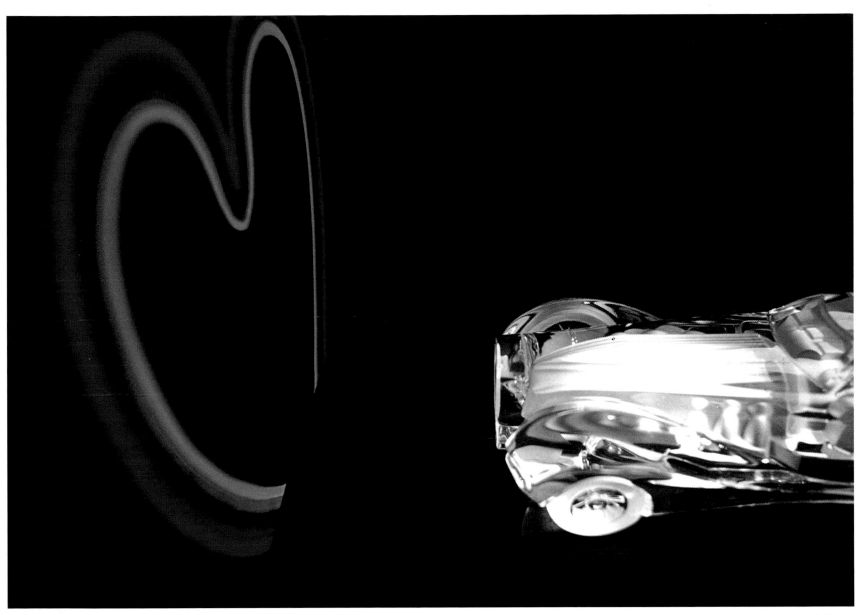

San Francisco, California

Rome, Italy

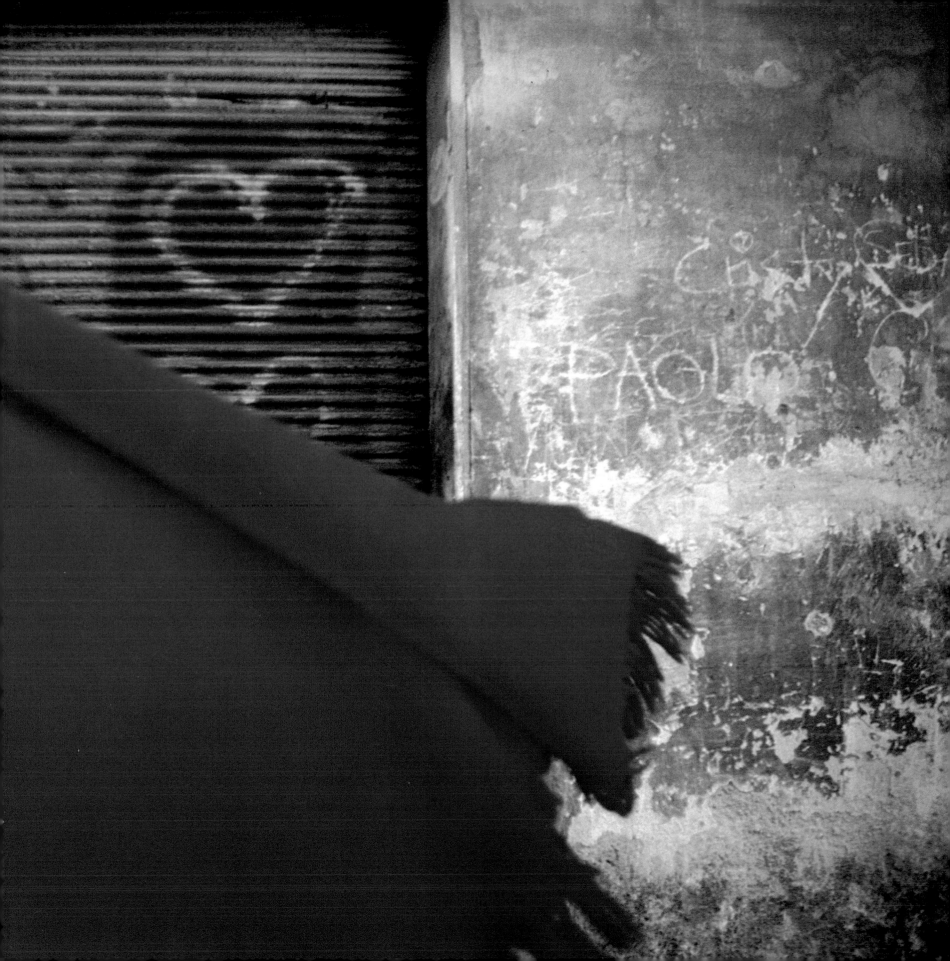

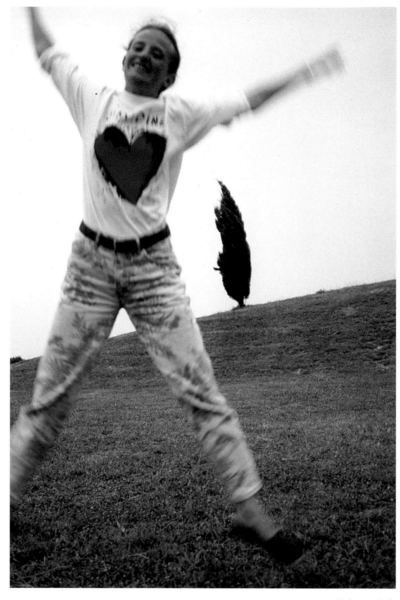

Bologna, Italy

Excerpts: Lord Byron, to Tom Moore, Letters and Journals; Beaumont and Fletcher, "Swift-winged Love"; Thomas Moore, untitled; John Lyly, "O Cupid!"; Eric Mackay, untitled; Emily Dickinson, #1567, reprinted by permission of the publishers and the Trustees of Amherst College from THE POEMS OF EMILY DICKINSON, edited by Thomas H. Johnson, Cambridge, Mass.: The Belknap Press of Harvard University Press, Copyright 1951, ©1955, 1979, 1983 by The President and Fellows of Harvard College; Lord Byron, Don Juan; George Berkeley, "There Shall Be Sung"; John Harrington, "Whence comes my Love?"; William Shakespeare, As You Like It, V, iv, 131-132; Emily Dickinson, #26; William Shakespeare, Romeo and Juliet, II, iii, 67-68; Thomas Love Peacock, "Oh! say not woman's heart is bought"; Charles Mordaunt, "Chloe"; William

Wordsworth, The Prelude, Book 5; Eric Mackay, Ninth Litany, "Lilium Inter Spinas"; Percy Bysshe Shelley, "On Love."

Photos from the Mrs. Helena Stuart Collection found on pages 3, 29, 31, 40, 41, 54, 55, appear courtesy of the Only Hearts shop in New York City.

The publisher has made a thorough effort to locate all persons having any rights or interests in material reprinted in this book, and to clear reprint permissions. If any required acknowledgments have been omitted or any rights overlooked, we regret the error and will make corrections in future editions of the book.